. . . but I wanted

a

*pony!*

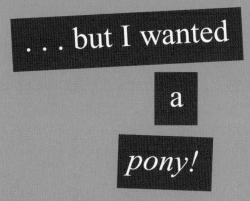

. . . but I wanted a *pony!*

An Anne Taintor Motherhood Collection

CHRONICLE BOOKS
SAN FRANCISCO

Library of Congress Cataloging-in-Publication Data:
Taintor, Anne.
  But I wanted a pony! : an Anne Taintor motherhood collection / Anne Taintor.
     p. cm.
  ISBN 978-1-4521-1448-4
  1. Mothers--Humor. 2. Motherhood--Humor.  I. Title.
  PN6231.M68T35 2013
  818'.602--dc23

                           2012025099

Manufactured in China

Designed by Emily Dubin

10 9 8 7 6 5 4

Chronicle Books LLC
680 Second Street
San Francisco, California 94107
www.chroniclebooks.com

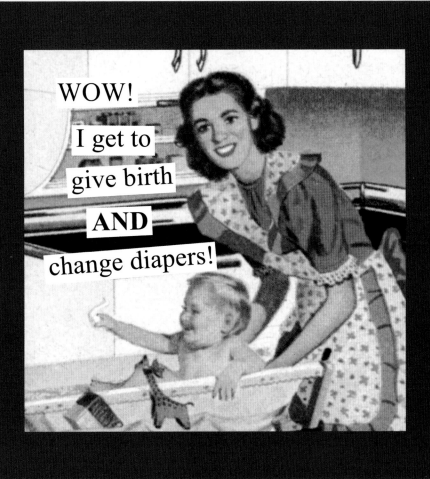

# Introduction

Not every mother gets—or even wants—to give birth *and* change diapers. I myself would have been just as happy to skip the "give birth" part.

Every other part of being a mother, though, has been unadulterated joy, from the very first diaper right up to the memorable 2 A.M. phone call from my eighteen-year-old daughter locked out of her apartment in a seedy urban neighborhood 2,000 miles away.

I love being a mother.

Having a mother is also quite nice. Sure, mom forgot me at a gas station in Virginia (I was ten) when my family was driving from Maine to Florida. And yes, she made me finish my scallops (ick) as I watched the good eaters in the family decorate the Christmas tree.

But she also kissed a heck of a lot of boo-boos, and just the fact that she didn't sell me to pirates when I was fifteen should qualify her for sainthood.

I love having a mother.

I'm not the sort of supermom glorified (and yes, mocked) in these pages. No well-stocked fridge ever brought a beatific smile to my face. No load of whiter whites and brighter brights ever elicited such joy. But when I ask "did we forget the children at baggage claim . . . again?" I am of course only joking. Motherhood is one of the best ideas anyone ever had; it makes me smile every day.

I hope the images in this book make you—and your mom—smile, too.

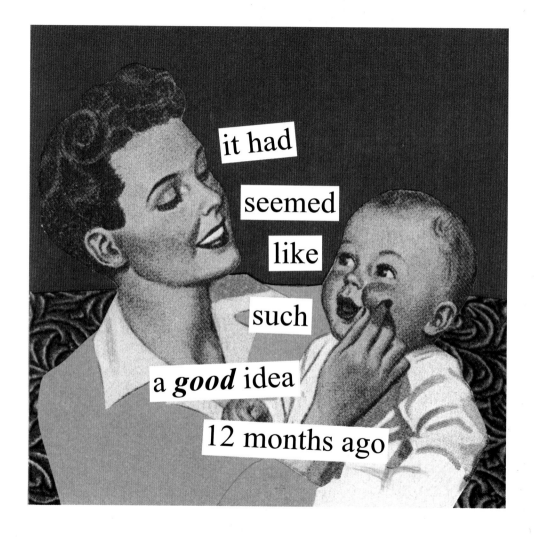

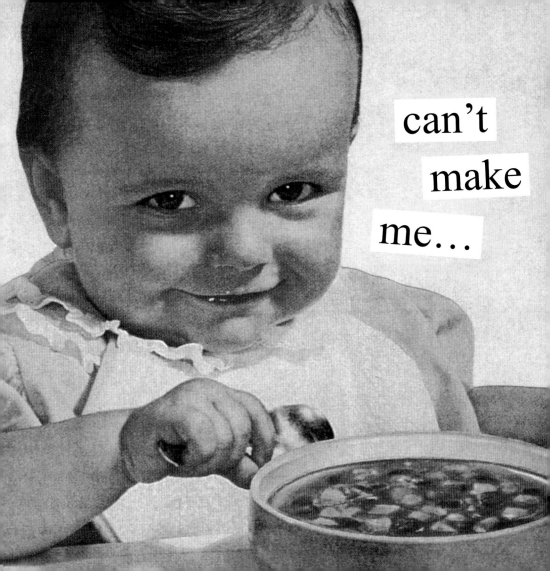
can't make me…

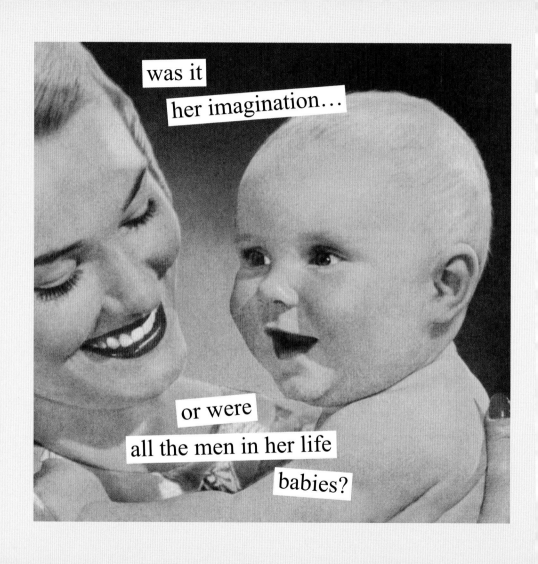

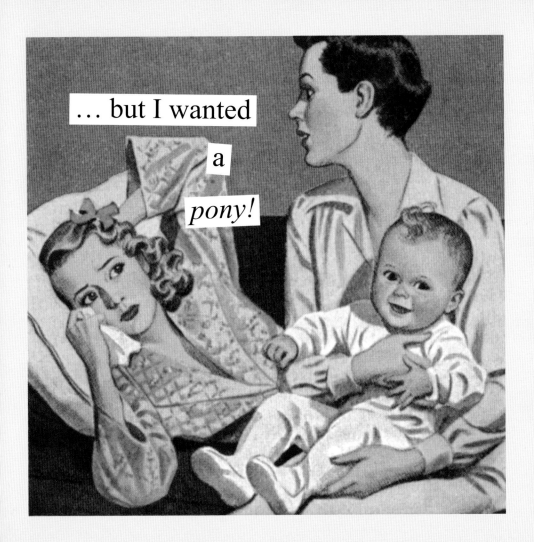

together
we will
***own***
your
grandparents

five martinis later,
she tried
to recall that rule
about babies and bathwater

I wish I may,

I wish I might,

get some frikkin' sleep tonight!

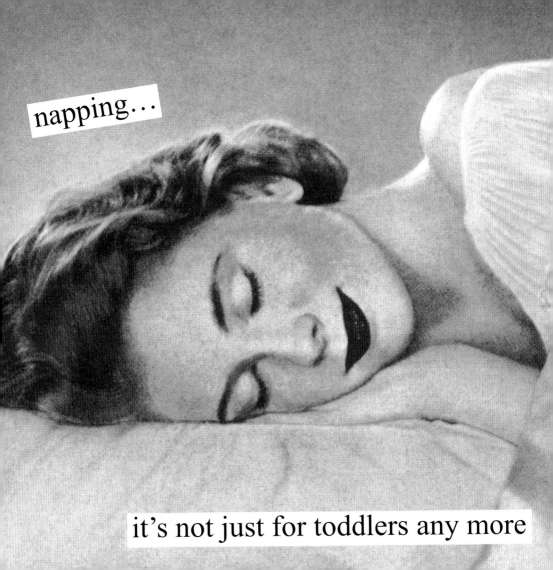

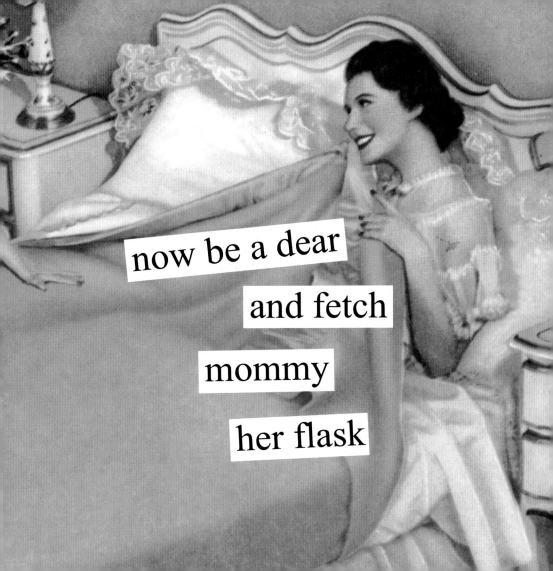

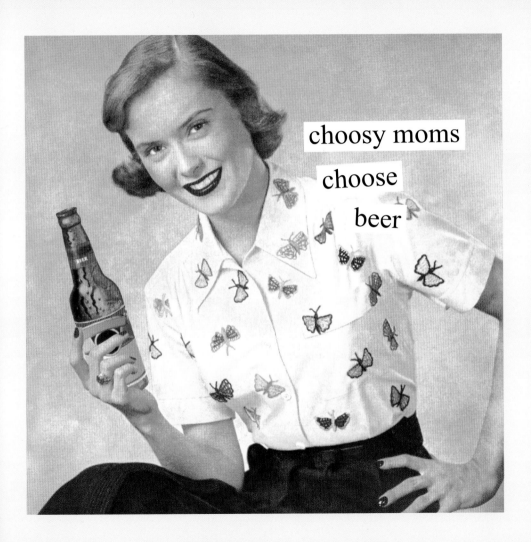

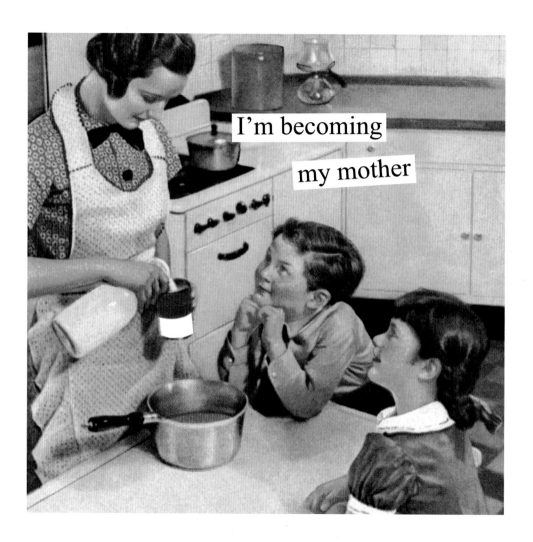

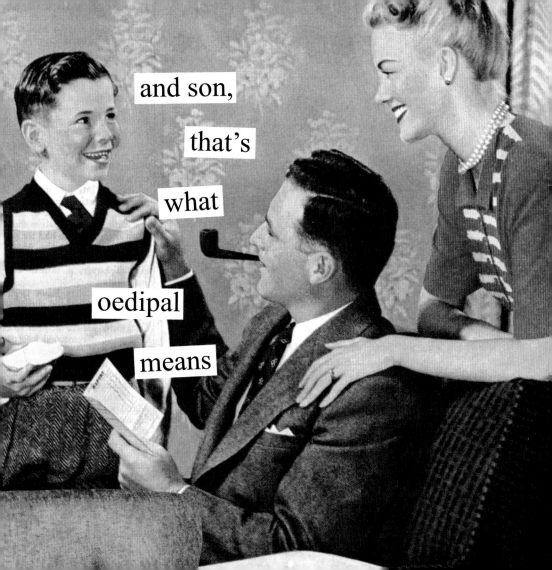

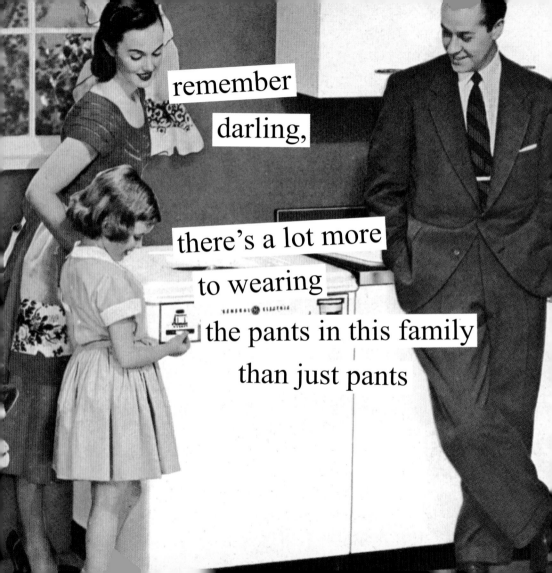

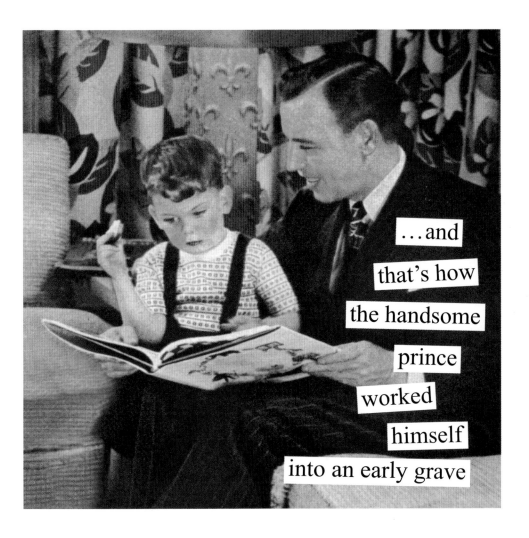

...and that's how the handsome prince worked himself into an early grave

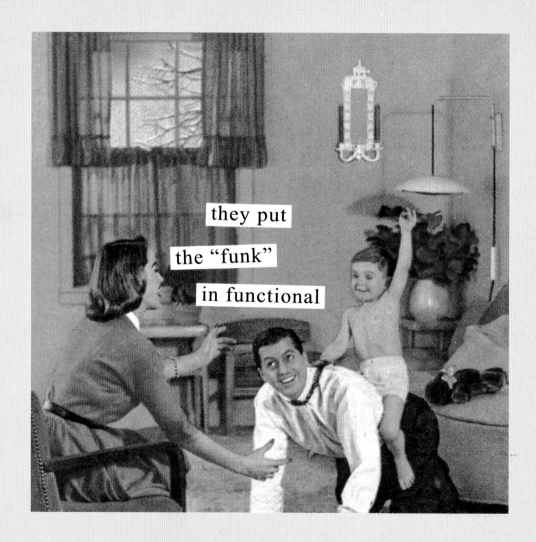

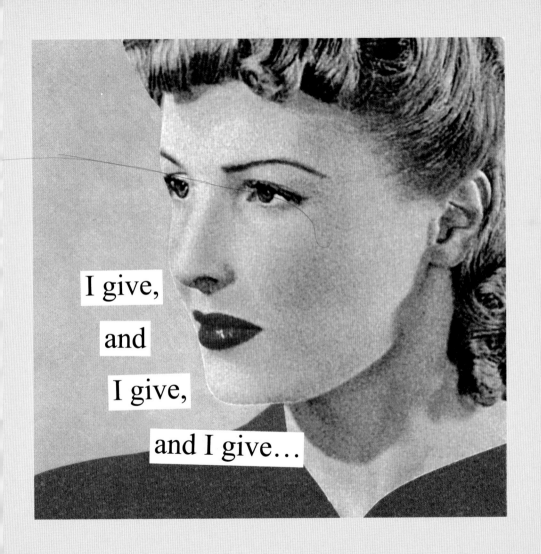

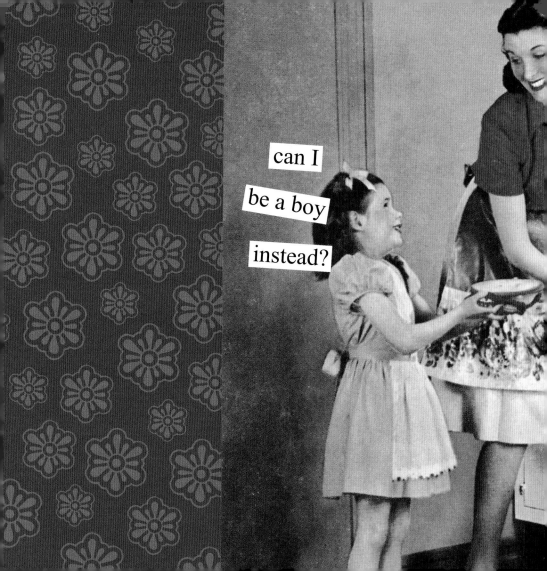

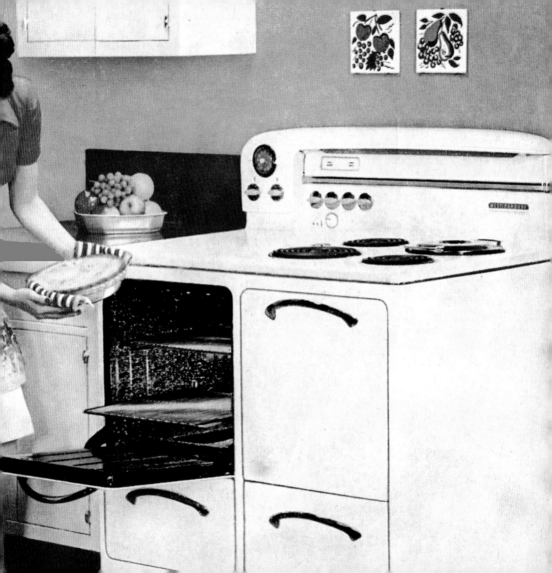

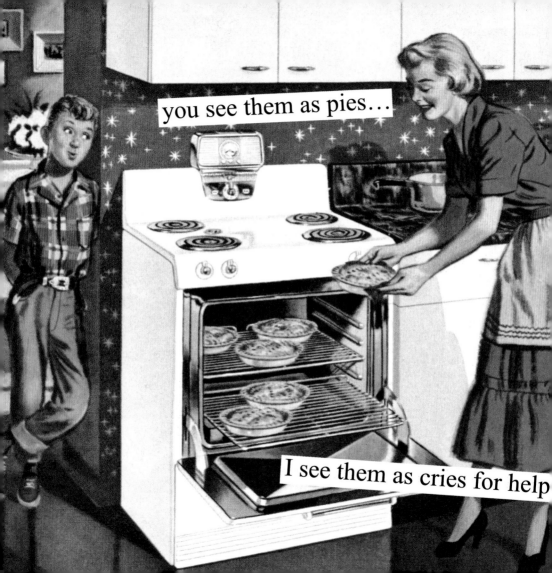

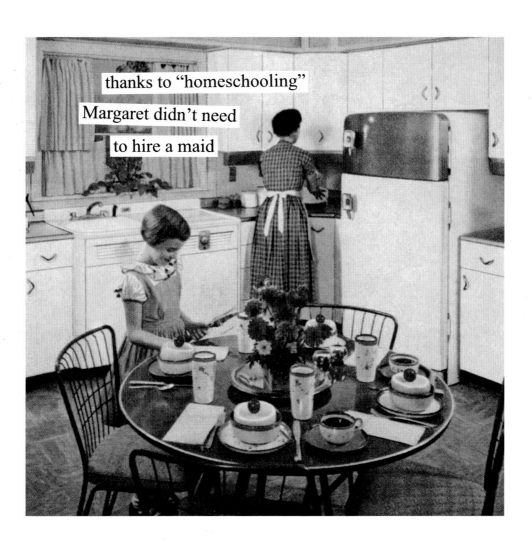

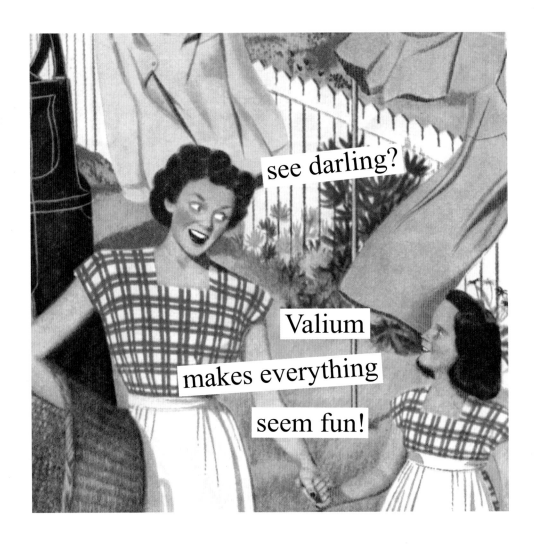

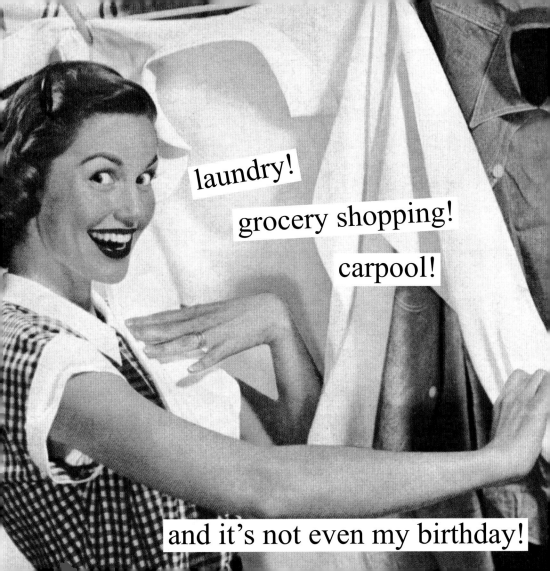

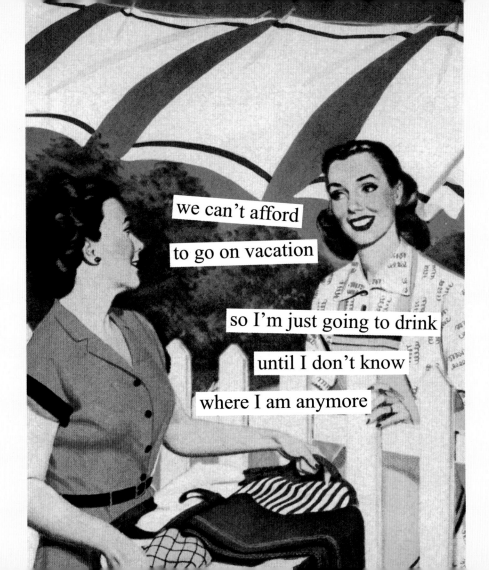

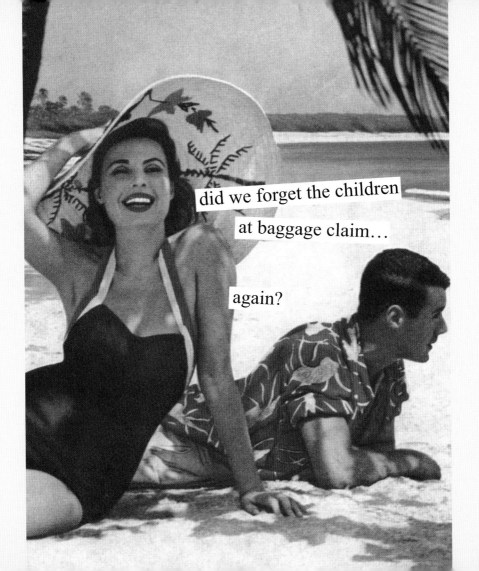

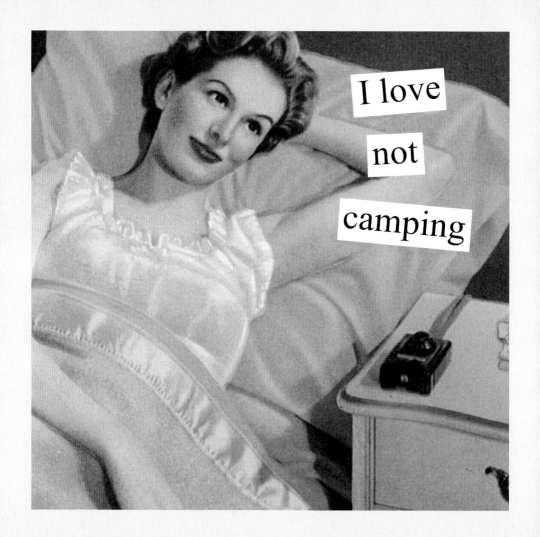

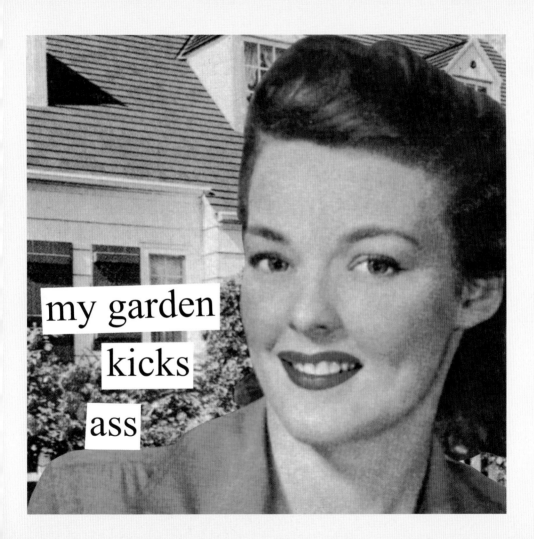

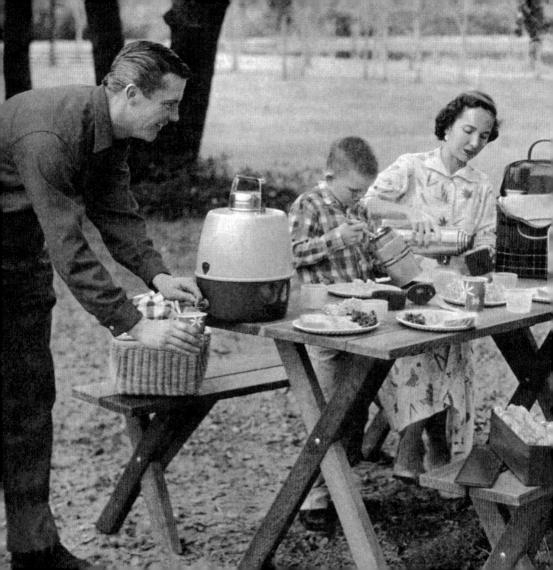

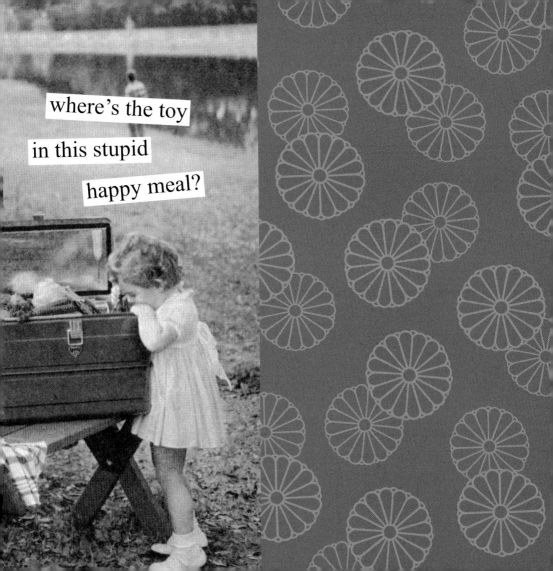

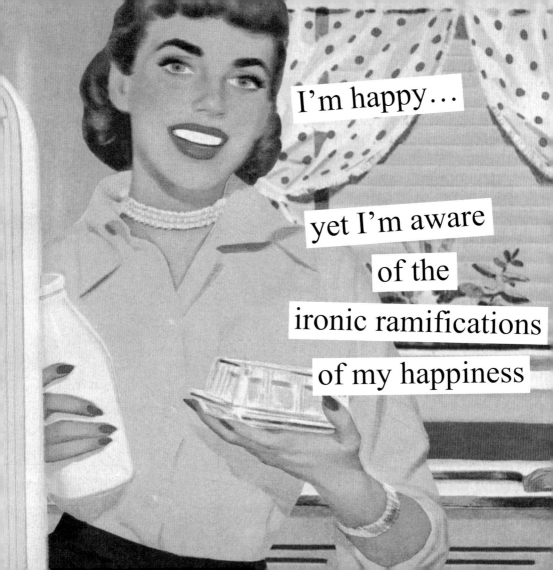

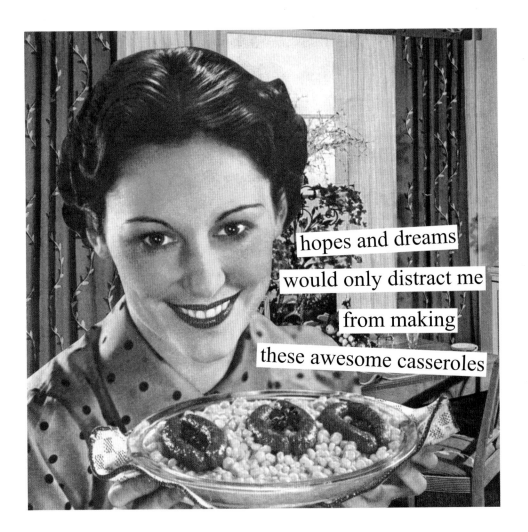

hopes and dreams

would only distract me

from making

these awesome casseroles

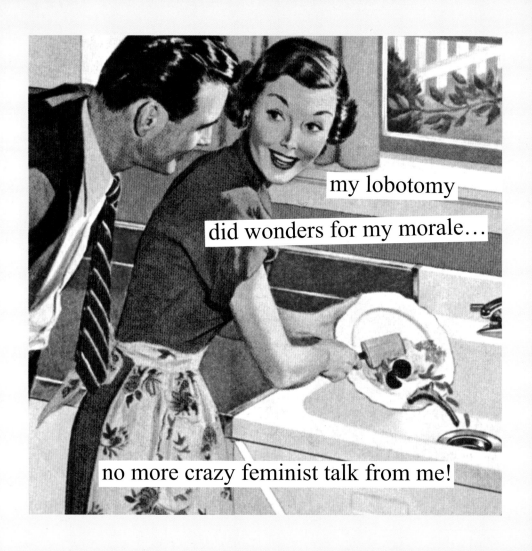

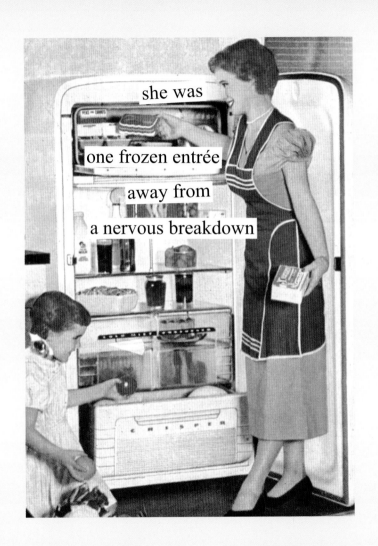

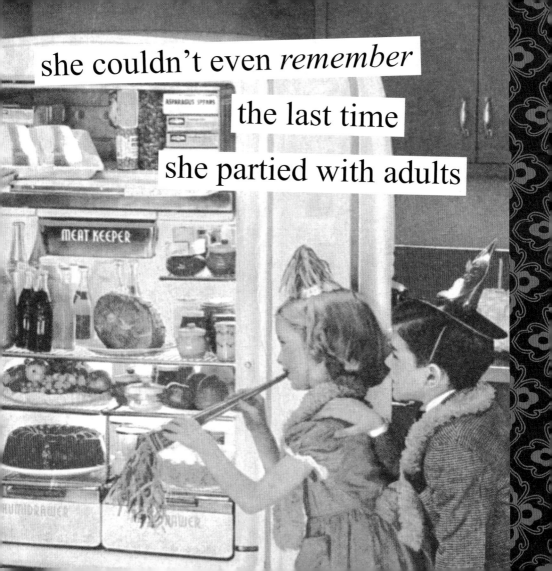

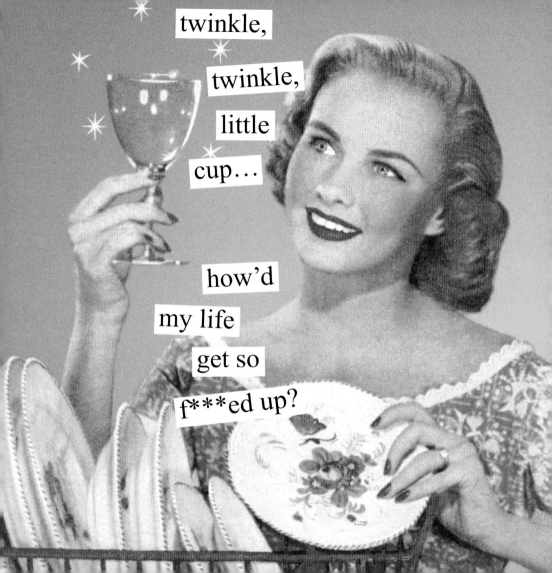

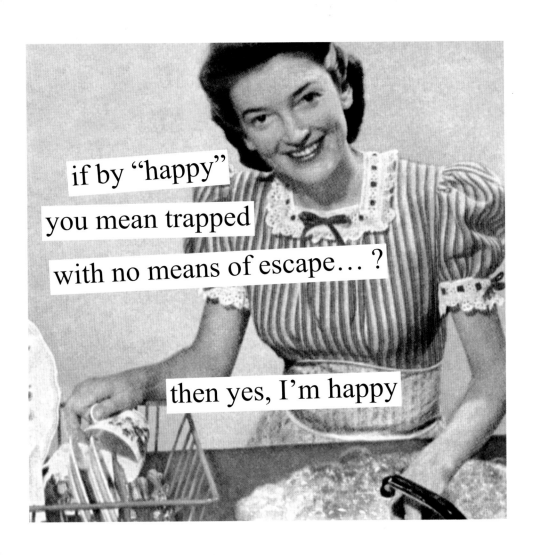

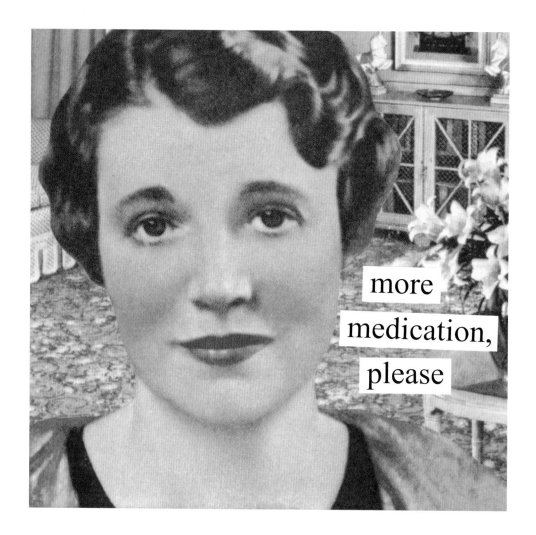

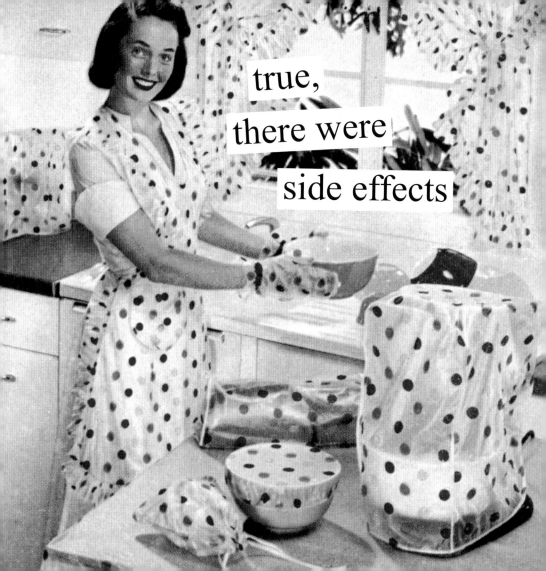

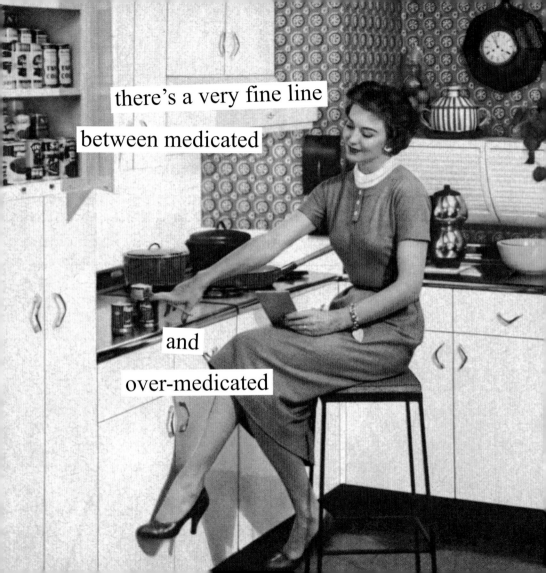

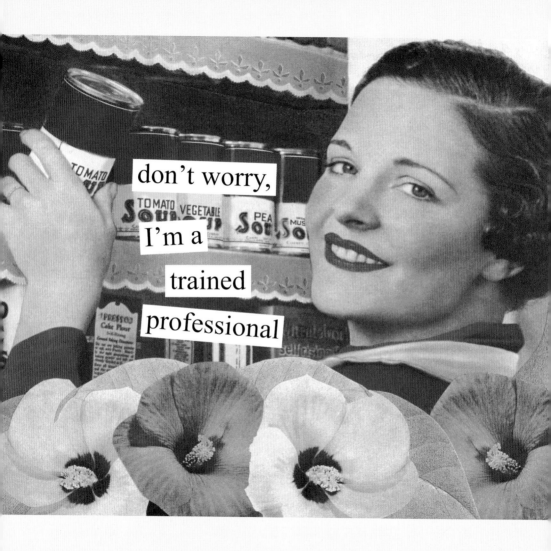

don't worry, I'm a trained professional

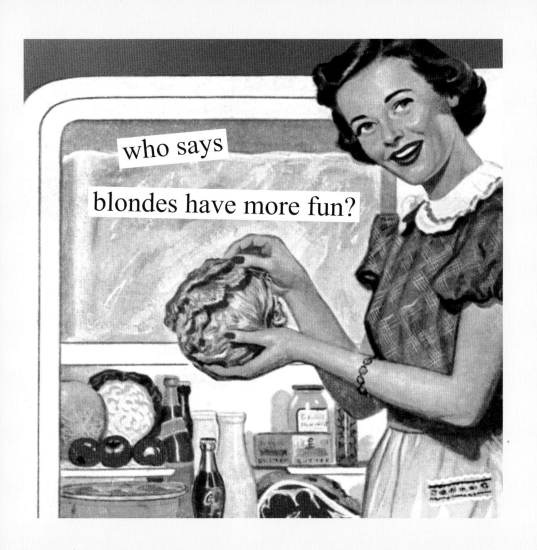

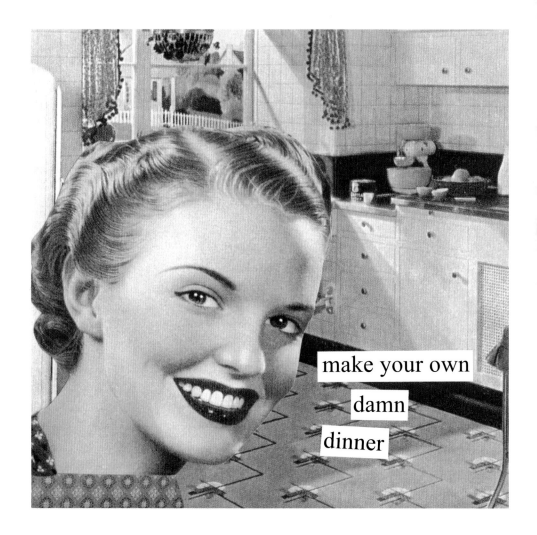

make your own

damn

dinner

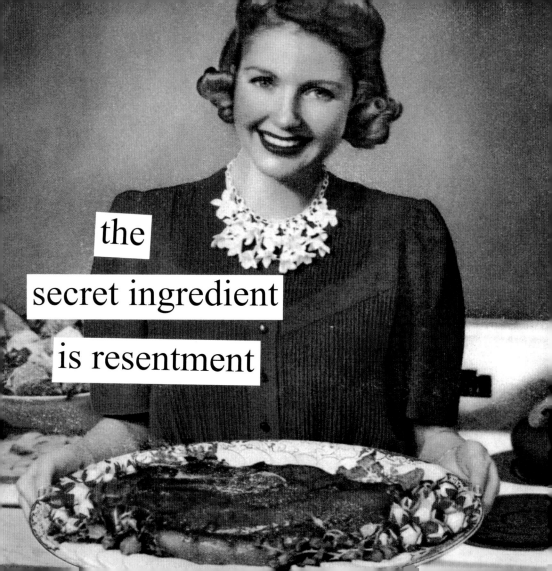

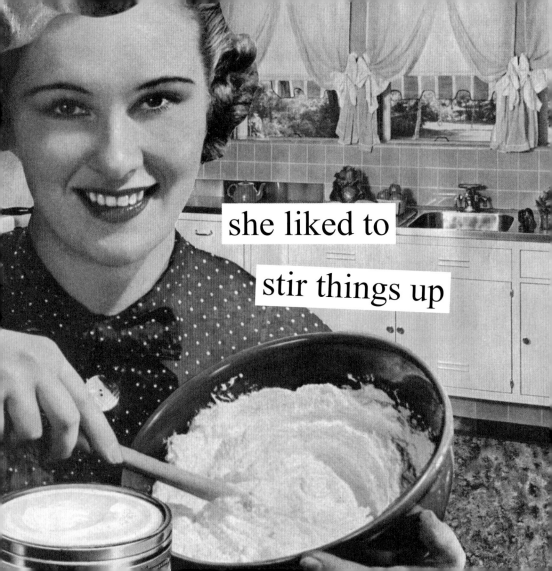

she liked to
stir things up

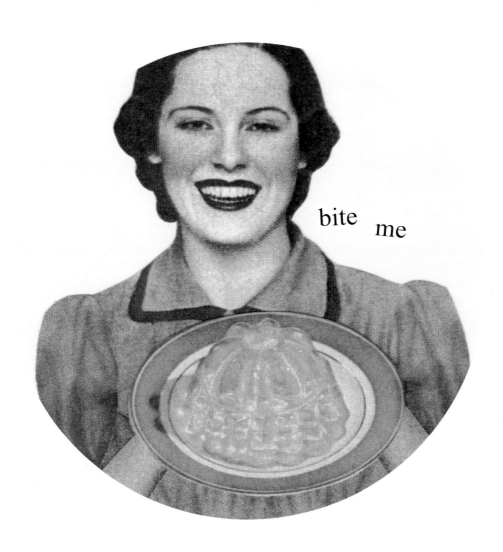

bite me

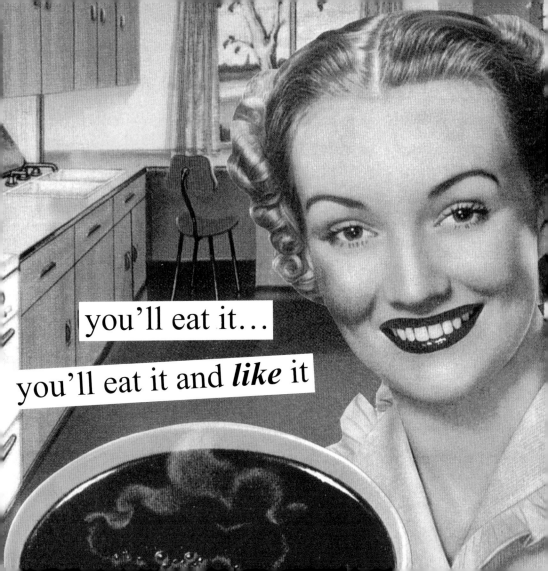

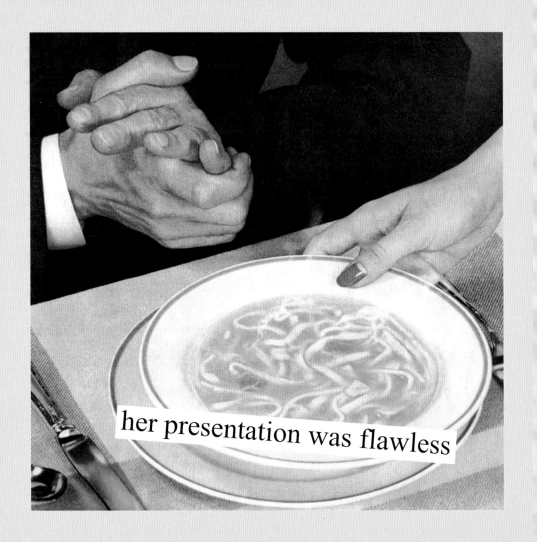

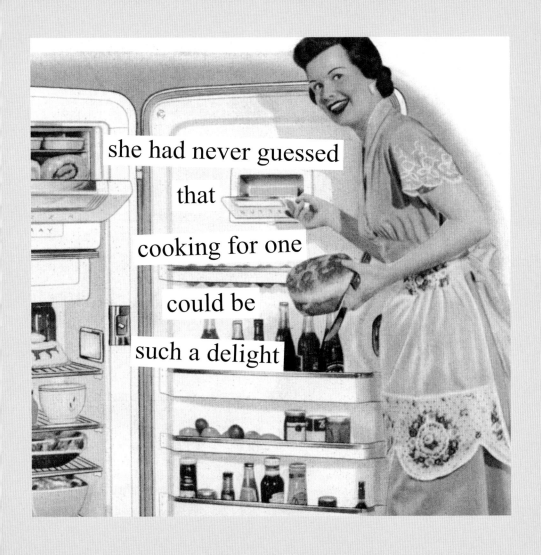

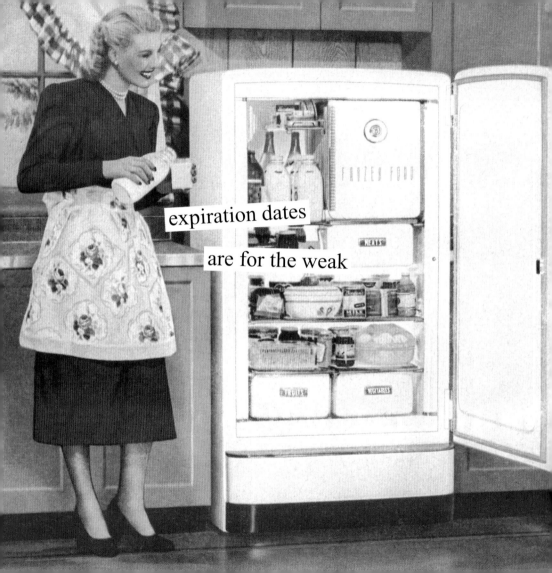

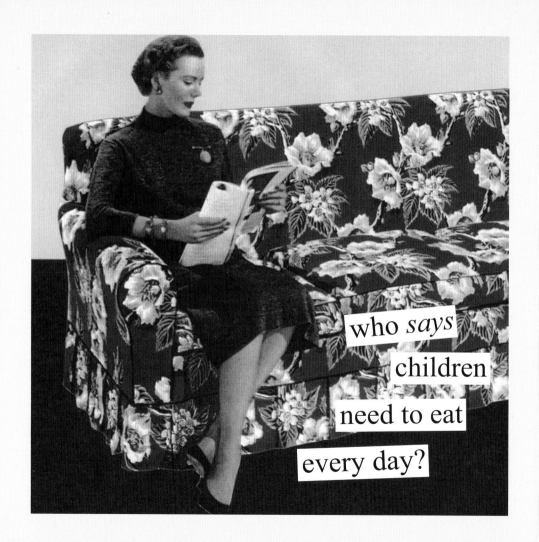

who *says* children need to eat every day?

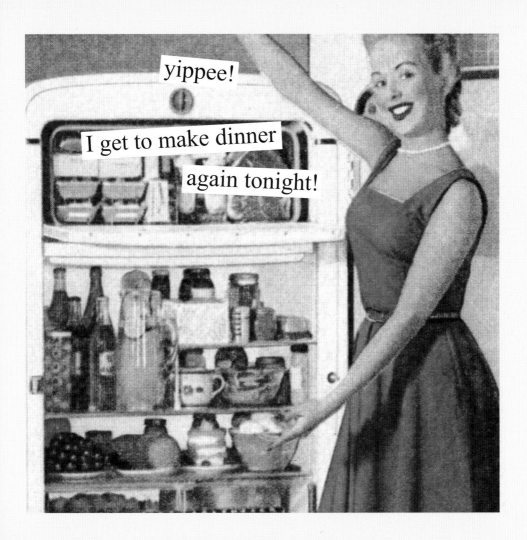

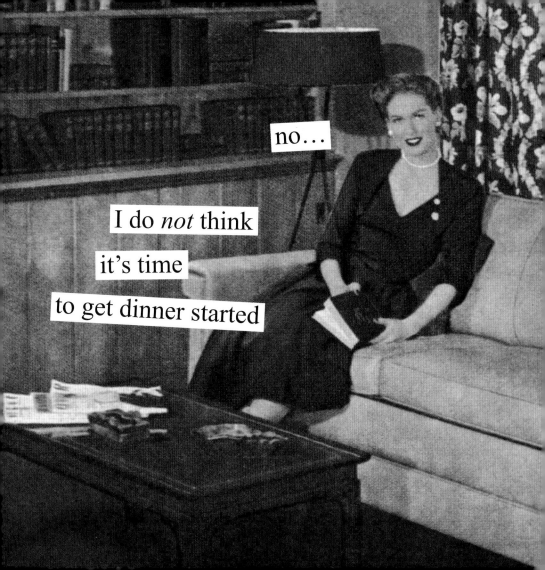

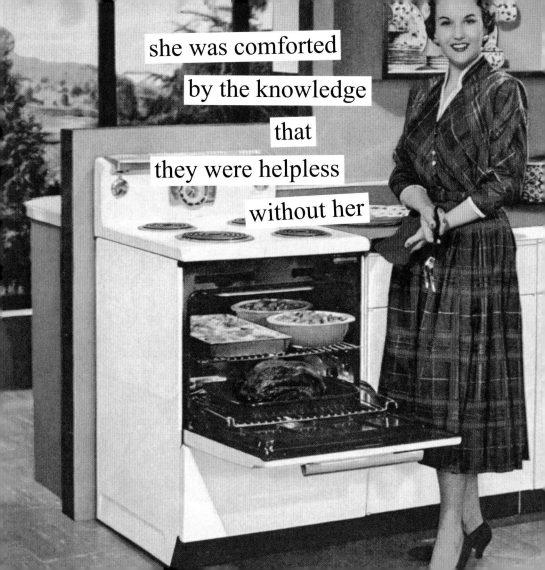

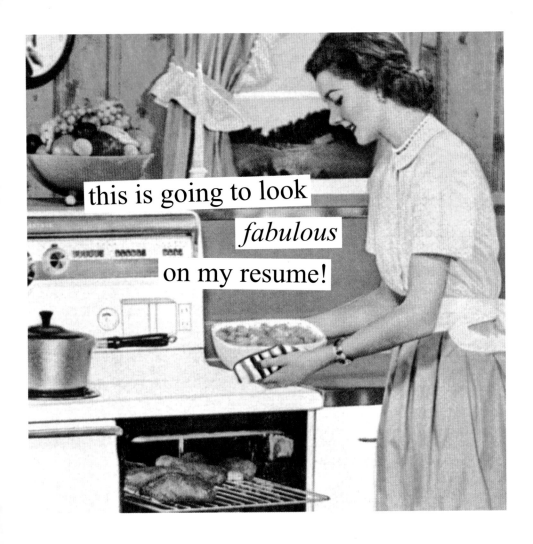

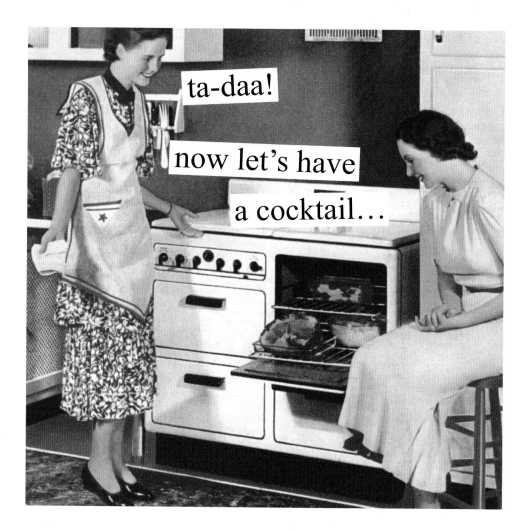

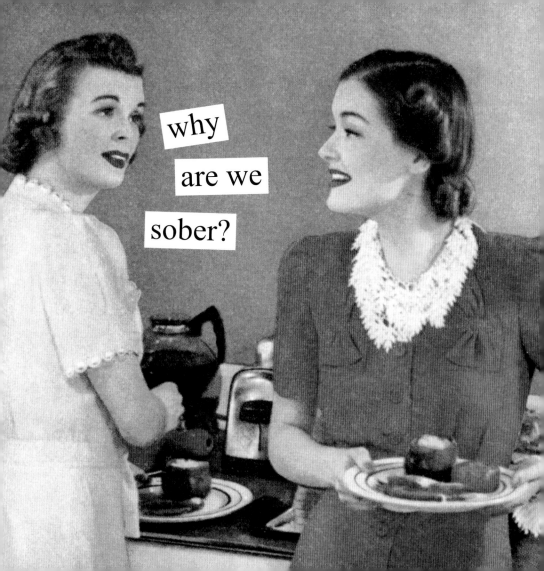

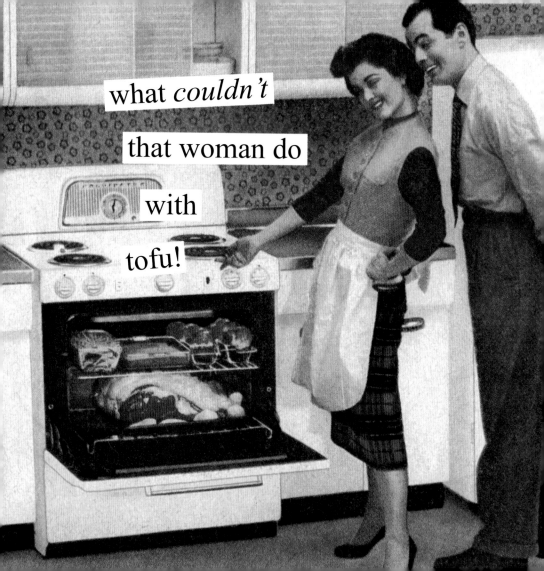

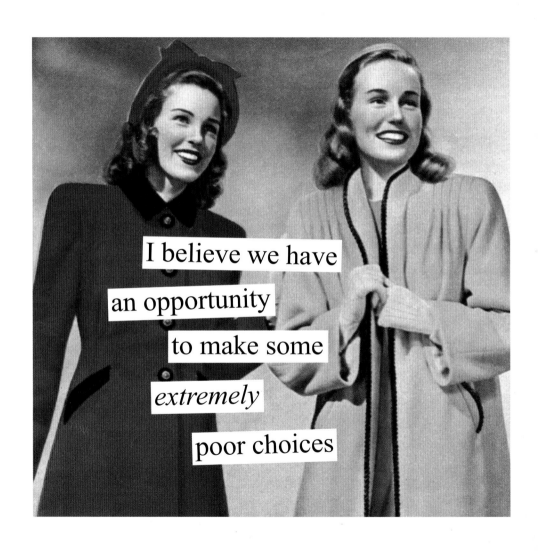

I believe we have an opportunity to make some *extremely* poor choices

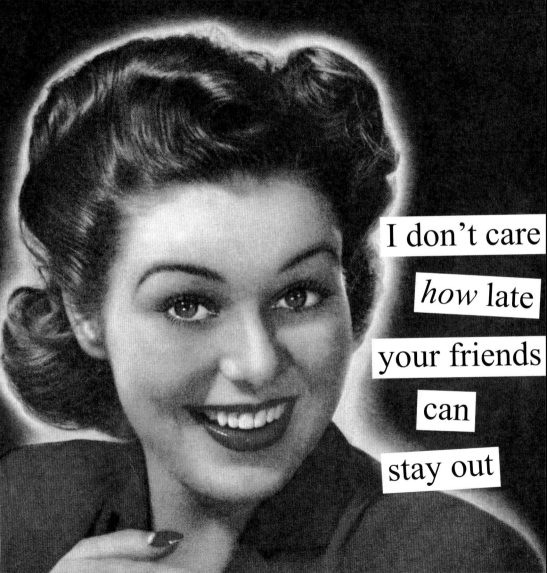

I don't care *how* late your friends can stay out

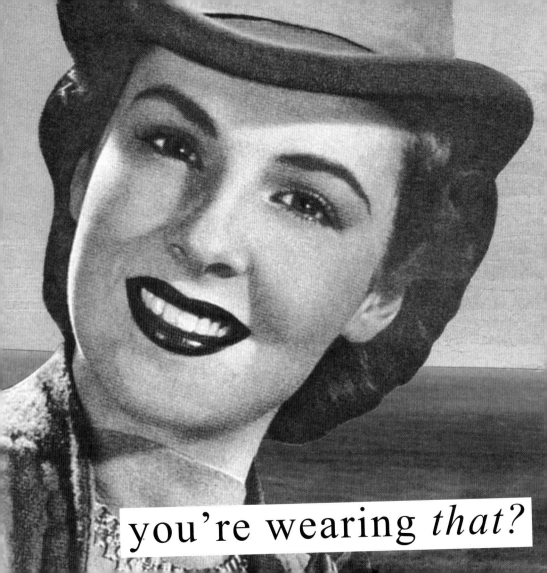
you're wearing *that*?

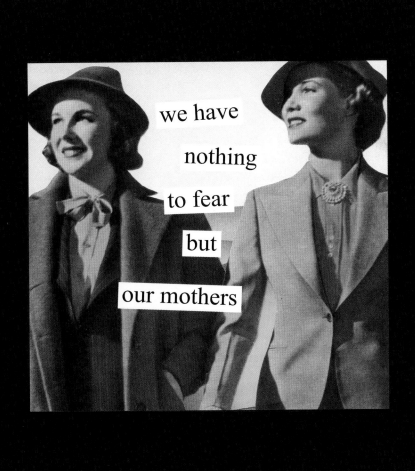

we have

nothing

to fear

but

our mothers

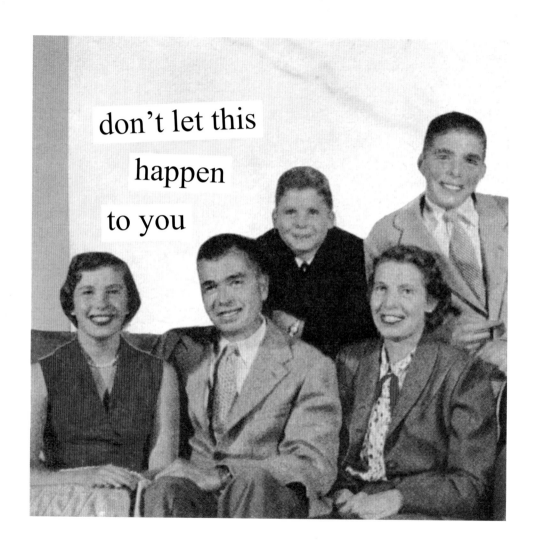

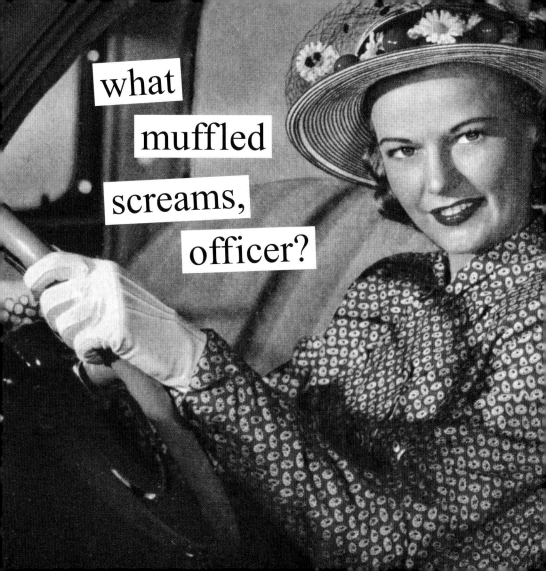

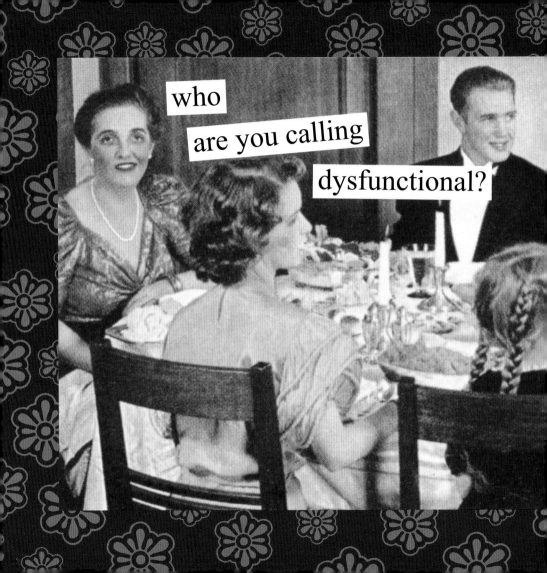

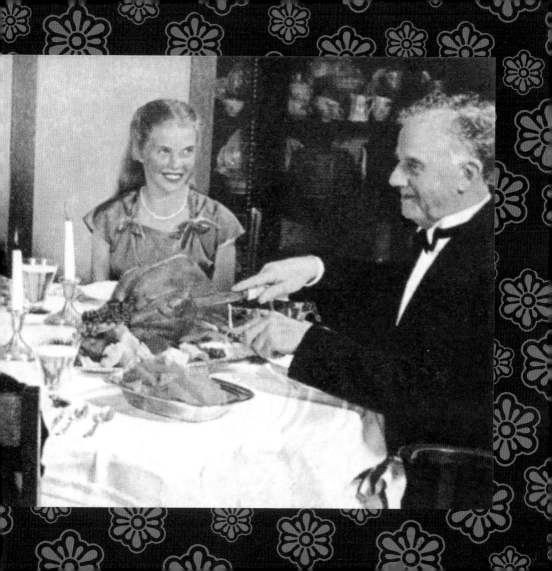

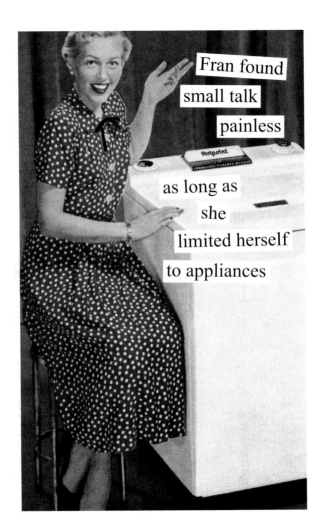

Fran found small talk painless as long as she limited herself to appliances

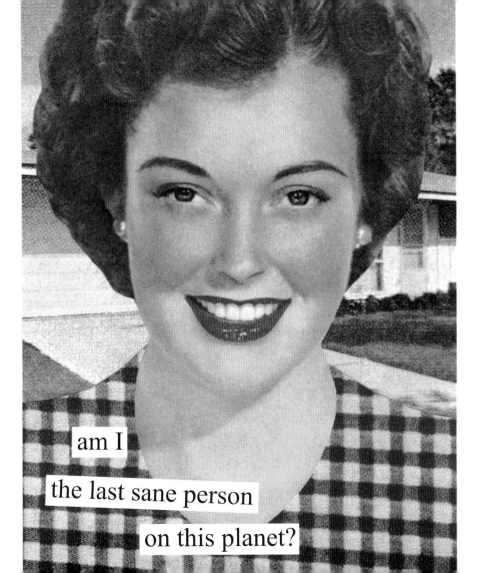

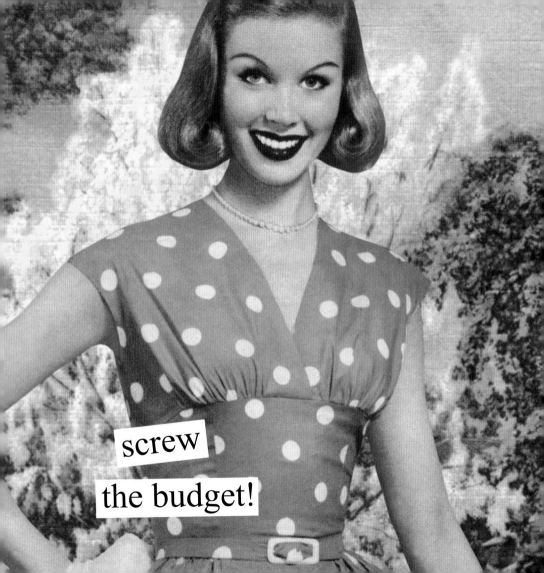

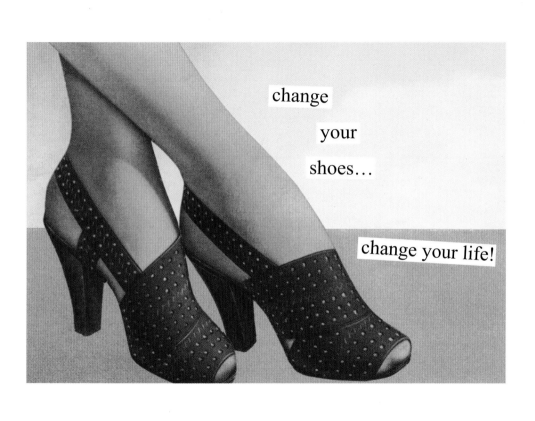

change

your

shoes…

change your life!

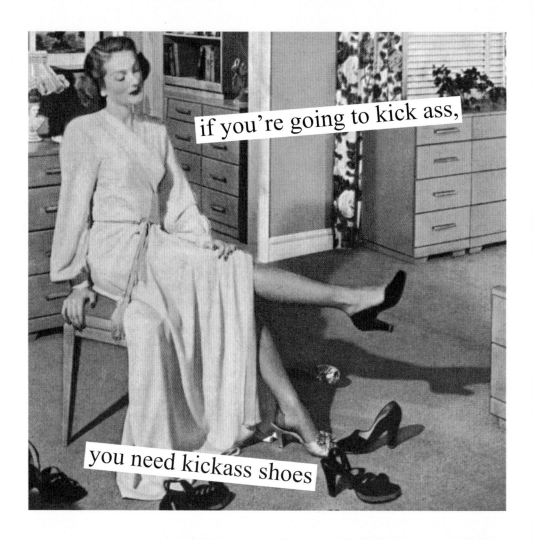

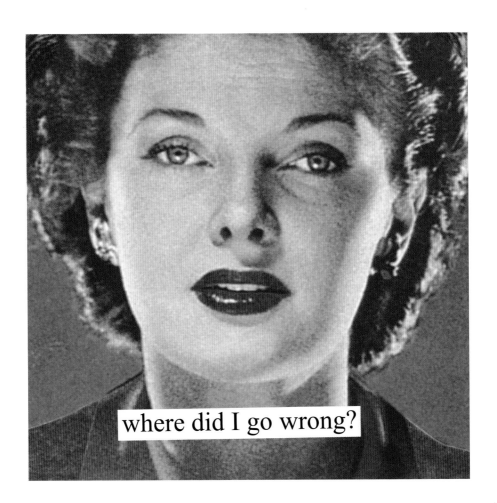

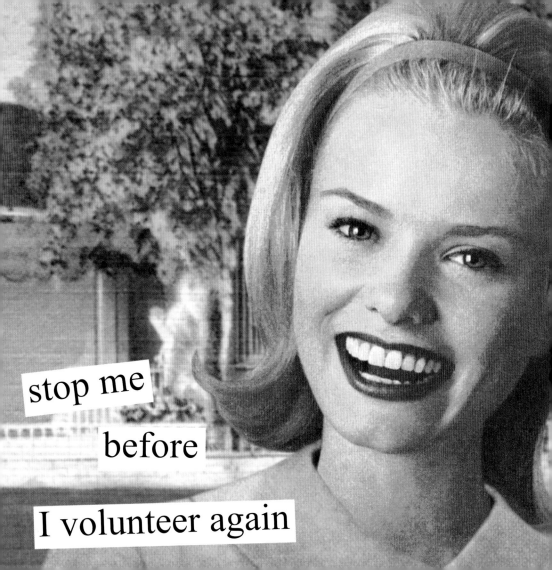

stop me

before

I volunteer again

what I really
want to do
is direct

curtains!

slipcovers!

this must be

heaven!

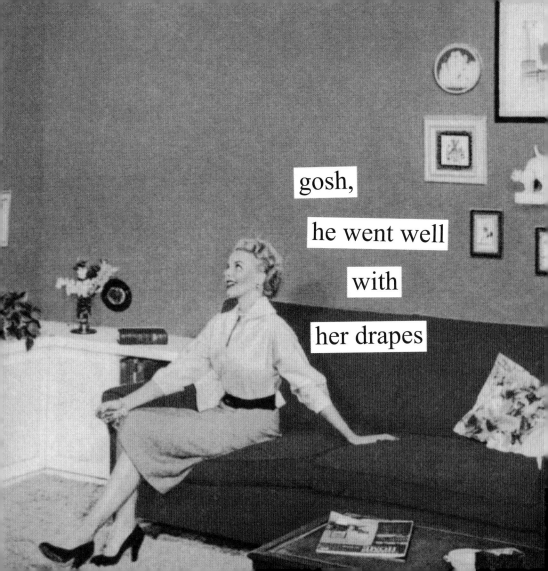

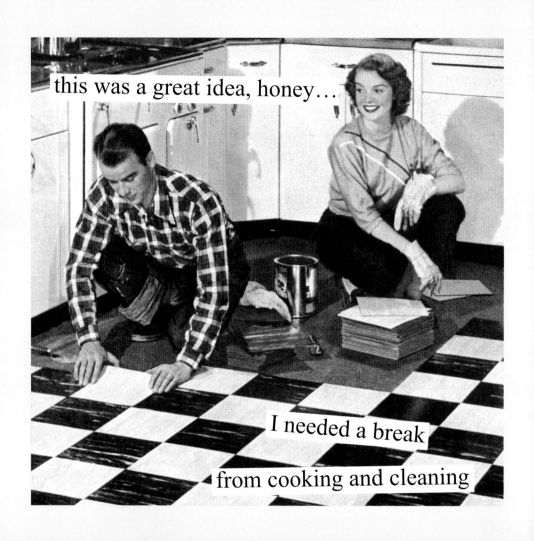

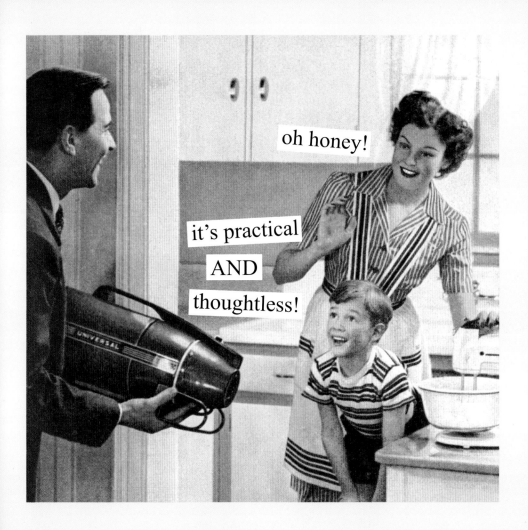

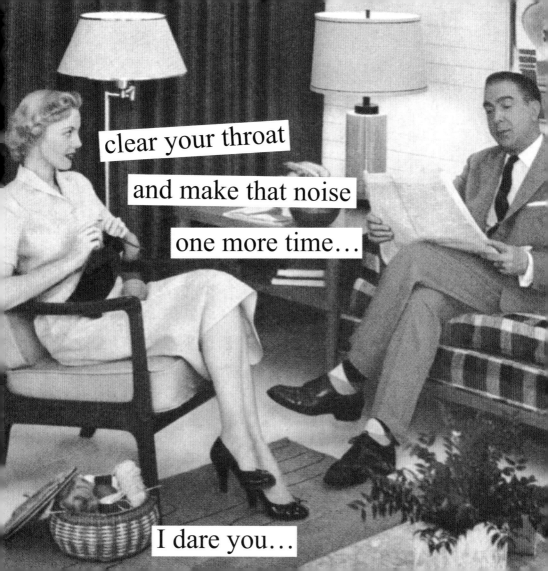

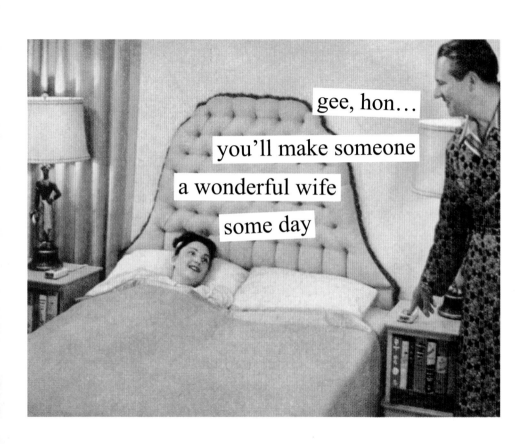

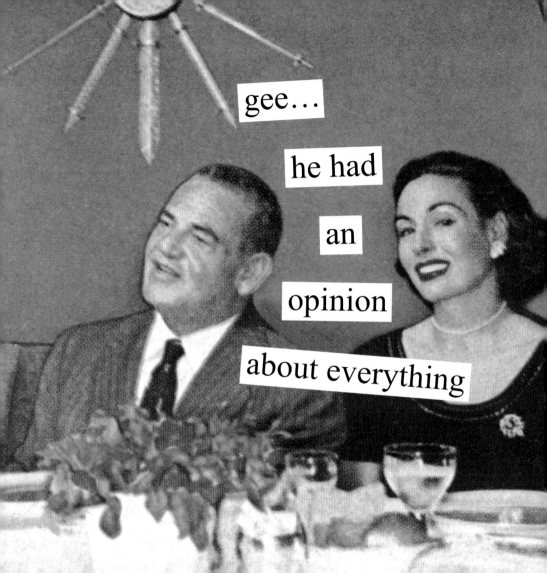

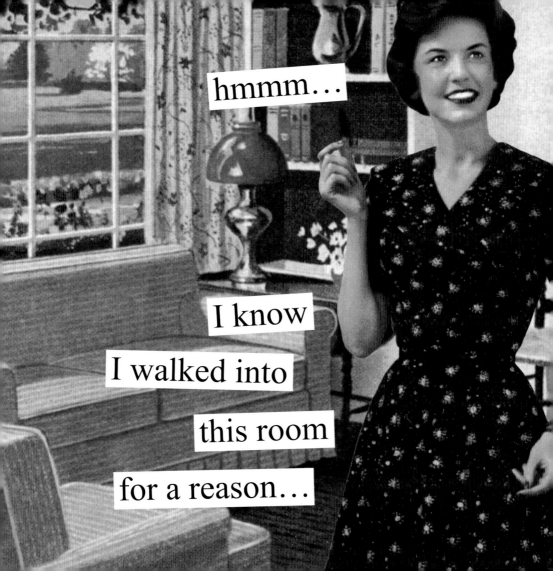

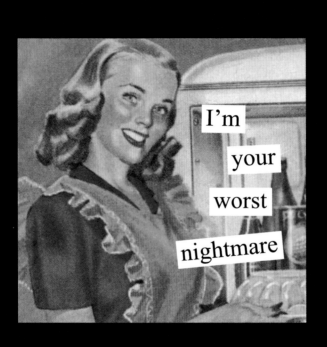

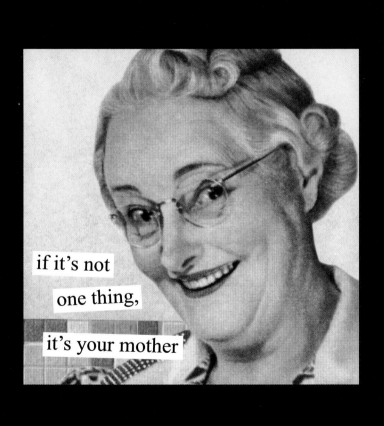

if it's not

one thing,

it's your mother

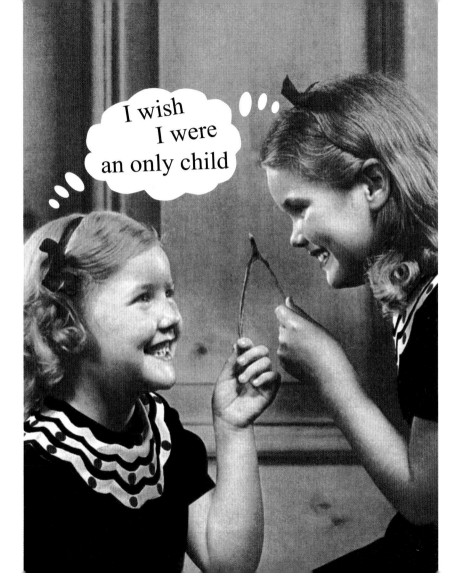

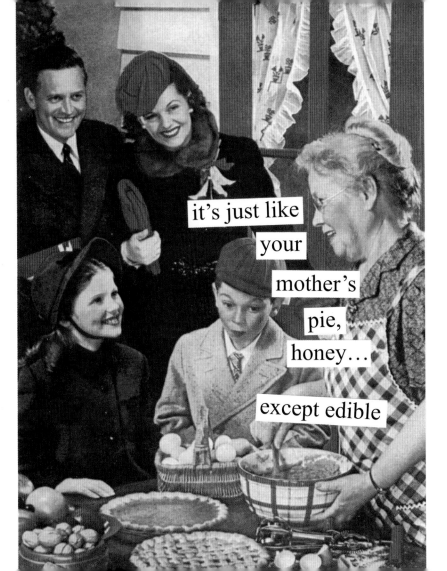

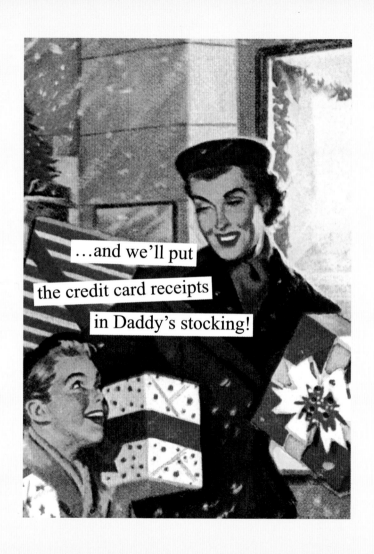

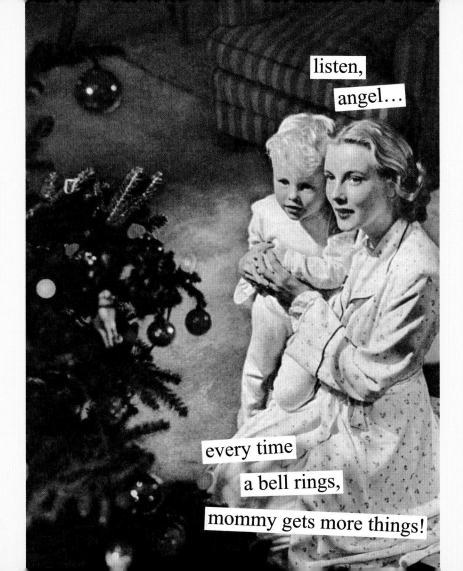

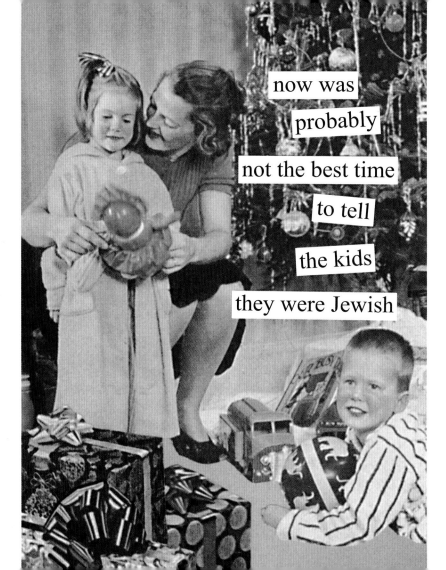

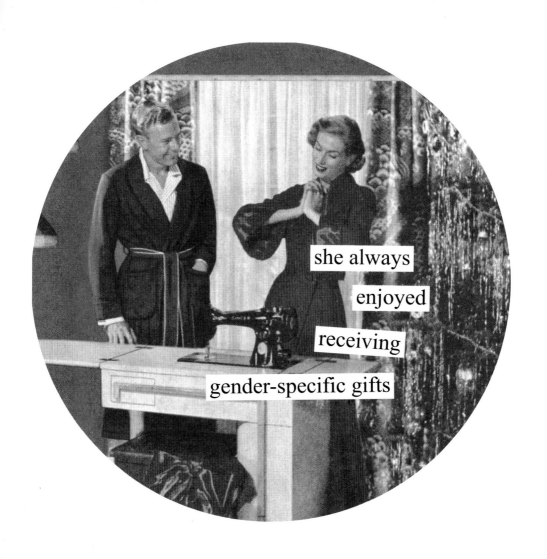

she always

enjoyed

receiving

gender-specific gifts

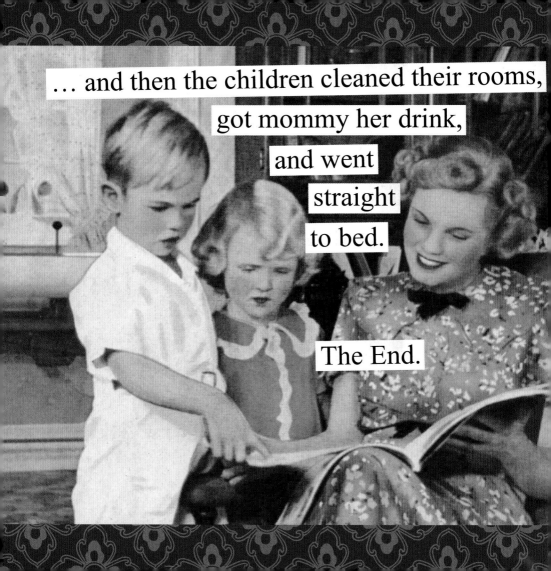

# Also Available from Anne Taintor

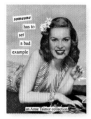

*Someone* Has To
Set A Bad Example

**An Anne Taintor
Collection**

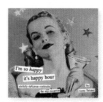

I'm So *Happy* It's
Happy Hour

**Sinfully Delicious
Cocktails for Any
Occasion**

I Feel A Sin
Coming On

**Postcards**

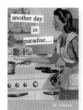

Another Day
In Paradise…

**Postcards**

She Had Not Yet
Decided Whether
To Use Her Powers
For Good Or For
Evil

**Journal**

Birthdays, She Believed,
Were No Time To
Exercise Restraint

**Birthday Book**

Wow, I Get To Give Birth
*And* Change Diapers?

**Photo Album**

See the full range of Anne Taintor books and gift products at www.chroniclebooks.com